NK
3243
.H56
1989

Hinchcliffe,
Frances.

Fifties furnishing
fabrics

$11.95

DATE		

ART SECTION
FINE ARTS DIVISION

© THE BAKER & TAYLOR CO.

THE VICTORIA AND ALBERT COLOUR BOOKS

LIBRARY OF CONGRESS CATALOGING-IN-PUBLICATION DATA

HINCHCLIFFE, FRANCES.
FIFTIES FURNISHING FABRICS / TEXT BY FRANCES HINCHCLIFFE.
P. CM. - (THE VICTORIA AND ALBERT COLOUR BOOKS)

ISBN 0-8109-3904-5

1. UPHOLSTERY - GREAT BRITAIN - HISTORY - 20TH CENTURY - THEMES,
MOTIVES. 2.VICTORIA AND ALBERT MUSEUM. I. VICTORIA AND ALBERT
MUSEUM. II. TITLE. III. SERIES.
NK3243.H56 1989
746.9 – DC 19 88-35719

COPYRIGHT © WEBB & BOWER (PUBLISHERS) LIMITED, EXETER.
THE TRUSTEES OF THE VICTORIA AND ALBERT MUSEUM, LONDON.
CARROLL, DEMPSEY & THIRKELL LIMITED 1989

BOOK, COVER AND SLIPCASE DESIGN BY CARROLL, DEMPSEY & THIRKELL LIMITED

PUBLISHED IN 1989 BY HARRY N. ABRAMS, INCORPORATED, NEW YORK
ALL RIGHTS RESERVED. NO PART OF THE CONTENTS OF THIS BOOK MAY BE
REPRODUCED WITHOUT THE WRITTEN PERMISSION OF THE PUBLISHER

A TIMES MIRROR COMPANY

TYPESET BY OPTIC

PRINTED AND BOUND IN HONG KONG

THE VICTORIA AND ALBERT COLOUR BOOKS

FIFTIES FURNISHING FABRICS

INTRODUCTION BY
FRANCES HINCHCLIFFE

HARRY N. ABRAMS, INC., PUBLISHERS
NEW YORK

INTRODUCTION

THE FABRICS illustrated in this volume are from the Victoria and Albert Museum's collection of twentieth-century textiles. Each year since the early 1930s the museum has acquired a selection of the latest and best of British furnishing fabrics, a policy largely made possible by the generosity of manufacturers who, on request, have given samples and lengths of fabric. The result is an extensive and varied collection illustrating major design innovations and featuring the work of many eminent artists, designers and enlightened producers. So-called 'contemporary' designs of the 1950s, printed in fresh, lively colours on sturdy cottons, linens and rayons, are especially well represented.

The term 'contemporary' conjures up visions of fluid abstract and semi-abstract flat forms, sometimes linked by spindly lines and punctuated by nodules. 1950s textile patterns were closely related to other design disci-plines, notably architecture and furniture. For example, the rhythmical curving 'quartic' shapes used by Marian Mahler (*plate 23*) recurred in many guises from wooden tables to ceramic dishes. Designs were often influenced by elements in modern painting and sculpture. 'Flotilla' and 'Trio' (*plates 25 and 5*) pay tribute to Joan Miró and Paul Klee.

Natural subjects provided a rich fund of source material. Stylized animal, plant and fruit forms such as the smiling fish and the ubiquitous lemon cut in half (*plates 21 and 14*) became common currency. Winged creatures were pop-ular. Lucienne Day provided Liberty's with 'Fritillary', horizontal bands of freely drawn butterflies in red, black and grey on white (*plate 20*). Sylvia

Chalmers perched angular cut-out birds, decorated with zigzags, checks and spots, on slender tree trunks to form a strong, vertical design titled 'Feathered Friends' (*plate 22*) for Elizabeth Eaton's London wholesale firm.

Skeleton plant forms standing in upright rows across the fabric 'Palisade' (*plate 1*) are typical ultra-modern motifs. Thin, spiky lines reflected architects' and furniture designers' current preoccupation with the tensile strength and slimness of steel components. Such patterns complemented the lightweight appearance of angular wire balustrades and the graceful curves of chairs created from thin steel rods or moulded plywood.

'Palisade' was commissioned from the young, talented freelance designer Lucienne Day by British Celanese, a producer of acetate rayon. Companion designs included the close-knit disciplined pattern of seemingly casual shapes 'Quadrille' (*plate 2*), and 'Perpetua' (*cover*), a composition of continuous movement reminiscent of inventions by the cartoonist Heath Robinson. Intended for curtaining they were screen-printed on Travacel slub rayon and rayon furnishing taffeta in twelve different colourways, and were marketed by Sanderson Fabrics at about 12s to 13s (60 to 65 pence) a yard.

British Celanese gave Lucienne Day a completely free hand, no stylistic or technical limitations were imposed, and she also provided the colourways. Initially only two designs were requested but having difficulty deciding which they liked best, Celanese took all the patterns submitted. Paul Reilly of the Council of Industrial Design applauded this bold experiment by a leading manufacturer and commented: 'The importance of this commission lies not only in the stature of the client but in the freedom of the designer. These patterns are not stepping stones bridging the gulf between the historical and the contemporary, nor halfway houses between the traditional and the experimental. They are boldly original and advanced – as original in our day as were the ancestral fabrics in theirs. It took courage to commission them; it will need faith and enthusiasm to market them. They are, too, a welcome reminder that the English tradition is to experiment.' (*Design*, number 43, 1952)

If any one fabric could be said to have caught the spirit of the age it must

be Lucienne Day's 'Calyx' (*plate 29*) exhibited at the Festival of Britain in 1951. The irregular cupped 'leaf' shapes linked by a delicate network of 'stems', far removed from the original inspiration in nature, were screen-printed on linen for Heal's. Several colourways were produced including lime green, turquoise and white on black, and elephant grey, orange and white on mustard yellow. The combination of muddy hues and sharp acid colours was as avant-garde as the motifs. 'Calyx' was awarded a Gold Medal at the 1951 Milan Triennale and the following year won the American Institute of Decorators' prize, awarded for the first time outside the United States.

The Festival of Britain was a national celebration which caught the imagination of the public. Work by leading British designers was assembled by the recently formed Council of Industrial Design to represent innovative and forward looking design. Specially produced fabrics were included in many locations. A compact but freely spaced arrangement of abstract shapes (similar to *plate 24*) by Jacqueline Groag hung in the Festival Information Centre in the London department store Swan and Edgar.

The furnishing and equipment of the Festival's South Bank Regatta Restaurant provided a centrepiece for an adventurous range of designs based on scientific diagrams recording the arrangement of atoms in materials including quartz, mica, nylon, polythene, haemoglobin and china clay. The idea was initiated by Mark Hartland Thomas of the Council of Industrial Design after consultation with Dr Helen Megaw of Girton College, Cambridge. He considered that: '...these crystal structure diagrams had the discipline of exact repetitive symmetry; they were above all very pretty and were full of rich variety, yet with a remarkable family likeness; they were essentially modern because the technique that constructed them was quite recent, and yet, like all successful decoration of the past, they derived from nature – although it was nature at a submicroscopic scale not previously revealed.' (*Design,* number 29-30, 1951)

Twenty-six leading manufacturers of dress materials, furnishing fabrics, pottery, glass, cutlery and flatware, floor-coverings, panelling, wallpaper, printing and packaging, furniture and fittings were invited to participate. It

was stressed that the crystal diagrams were only a source of inspiration for creative work, not a ready made shortcut to good design. S M Slade's fluid, amoebic shapes for British Celanese (*plate 10*) make play with the contour type diagram of Afwillite, a naturally occuring mineral. Although intended as a dress fabric the design would have been equally suitable for furnishing.

Bright, airy, free-form patterns heralded an optimistic future and re-

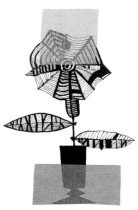

flected modern informality in living. They were a welcome relief from the austerity of the war years when furnishings were restricted to small repeats and drab colours as production was limited and yarns, fabric and dyes were in short supply. Con-temporary designs were also a departure from the 1930s vogue for plain or minimally decorated fur-nishings in shades of cream, beige and white. Modern design had moved away from the geomet-rical precision of a strictly functional phase to some-thing more friendly and relaxed: '... where the pre-war moderns extolled boldness, simplicity, economy and logic, the critics today look for lightness, elegance and charm, but without, be it noted, any wishful recalling of past styles.' (Paul Reilly, *De-sign,* number 44, 1952)

A leading British export journal stated: 'Most British manufacturers today are offering a wide range of both traditional and modern designs – and have been able to find any number of young designers whose freshness of outlook will ensure no bad copying in the future. This state of affairs is, happily, pros-pering because once more (after a lapse of nearly ten years) contemporary design, as it is generally found, is no longer "phoney." The "Chi-chi" of between the wars is as dead as the Dodo. The emphasis on movement which nowadays dominates all our life is naturally having its effect – and our vision has come to be dynamic. The still, objective (*sic*) sight of the cluttered up and immobile Victorian room has given place to light and air, grace and pace. Colour has itself contributed to motion, and the breaking up of texture has

provided not only new patterns, but provided the movement which our post-war eyes demand.' (*Ambassador,* the British Export Journal, number 7, 1952)

The article devoted a double page illustration to a selection of fabrics produced by David Whitehead, captioned 'The intelligent use of contemporary British designers gives the furnishing fabrics of D Whitehead Ltd, Rawtenstall, their special stamp'. The textiles were photographed on a fine steel rod structure, alongside a cone-shaped wire chair with seated poodle, in a breezy springtime garden. They included Terence Conran's irregular grid containing blocks of colour and controlled scribbles and splodges (*plate 28*), and Jacqueline Groag's eloquently drawn columns, urns and church windows (*plate 26*), a modification of a design originally commissioned by the Rayon Design Centre.

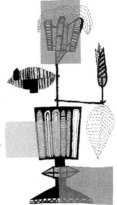

David Whitehead Ltd, a long established Lancashire cotton firm, became one of the foremost producers of 'contemporary' furnishing fabrics. In 1948 John T Murray, an architect with no previous experience in the textile industry, was apppointed as general manager and subsequently made a director, in the firm belief that to obtain good design a professional with design training should be responsible for production. He was particularly successful in appreciating and judging the competing claims of commerce and aesthetics and strongly maintained that if standards were to be raised manufacturers should be prepared to allocate a percentage of their effort to experimental designs although they might not sell. Fellow members of the furnishing trade were criticized for their lack of experimentation. 'Far too few are prepared to study the designer's point of view, to visit design centres, to read recent books, to study contemporary trends in the visual arts and their implications for textile design. The average manufacturer or retailer is far too ready to accept design standards as he finds them.' (John T Murray, *Furnishing,* the Magazine for the Furnishing Trade, June 1950)

A 'prestige' collection of furnishings was screen-printed by hand on

cotton and ranged from plain weaves and smooth sateens to the heavy, rough textured fabric used for Terence Conran's effective two-colour compositions of lines and blobs (*plate 18*). Many of the same designs were also machine roller-printed on spun rayon for 'the large and rapidly growing number of perople of taste who, whatever their means, are anxious to buy the best in design and colour'. Advertised by such slogans as 'Fresh gaiety that costs little', 'Moderate in price but high in style' and 'Light-hearted fabrics – lightly priced', this cheaper range retailed mostly at under 10s (50 pence) a yard, 48 inches (1.2 metres) wide.

Avant-garde design was no longer the preserve of an élite. Longer yar-dages printed by machine on less expensive materials substantially lowered costs, bringing stylish furnishings within the range of a wider market. Fuelled by the Festival of Britain, the Council of Industrial Design's educa-tion programme for retailers and consumers, and the activities of the Cotton Board and the Rayon Federation, the public's awareness and demand for good contemporary design were steadily growing. New, reasonably priced furnishing fabrics proved that making money and making fine things need not be mutually exclusive – 'the cheap need not be cheap-and-nasty'.

Firms with progressive design policies, including Heal's, Liberty's, and Whitehead's, purchased and commissioned work from leading freelance designers. Several, like Jacqueline Groag and Lucienne Day, were members of the Society of Industrial Artists (established in 1930 and now the Char-tered Society of Designers). Many had attended art school specialist textile courses. Lucienne Day studied at the Royal College of Art in the late 1930s and Terence Conran at the Central School of Arts and Crafts from 1949 to 1950. The Scottish designer Robert Stewart, head of the Printed Textile Department at Glasgow School of Art, produced many striking 1950s pat-terns for Liberty's, ranging from the purely abstract dish shapes balanced in vertical columns (*plate 13*) to the recognizable facial features of 'Masks' and 'Sunman' (*plates 19 and 4*).

Textiles were the success story of Heal's Wholesale and Export, set up during the war as a subsidiary of the London retailers Heal and Sons. Under

the direction of Tom Worthington and Prudence Maufe, young designers were given encouragement and their work fully credited on the fabric's selvedges. Heal's produced many of Lucienne Day's designs, including the award winning 'Calyx'. In 1954 the graceful linear design 'Herb Anthony', in white on black enlivened with touches of orange and yellow (*plate 16*), was their best seller. These designs were printed on crisp linen and cotton, but Heal's did not eschew man-made fibres. The rough lines of brightly coloured buoys on a textured sea, aptly named 'Flotilla' (*plate 25*), is well suited to the soft spun rayon on which it is printed. Harder edged designs 'Triad' (*plate 30*) and June Lyon's 'Mobile' (*plate 15*) are given sharper definition on a heavy, lustrous rayon satin.

Liberty's of London embraced the modern alongside their famous traditional florals. Goods with 'contemporary' designs from all departments were brought together in the 'Young Liberty' shop launched in 1949. Up-to-date design was not new to this prestigious store. '...Liberty's has gone from strength to strength...there is no shop in London that can claim to be more contemporary minded than Liberty's – which is to be expected, since Liberty's has been "contemporary" long before "contemporary" took on its present meaning.' (*Ambassador*, the British Export Journal, number 5, 1953)

By the mid 1950s the 'contemporary' style was changing. Designers were moving away from spindly lines juxtaposed with flat areas of colour, and repeats were growing larger in anticipation of the huge-scale architectural patterns of the 1960s. The role of professional freelance designers was by now firmly established. Traditional design still held a share of the furnishing market but the modern had won acceptance for use in every type of building from domestic interiors to hotels, offices, hospitals and schools.

THE PLATES

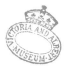

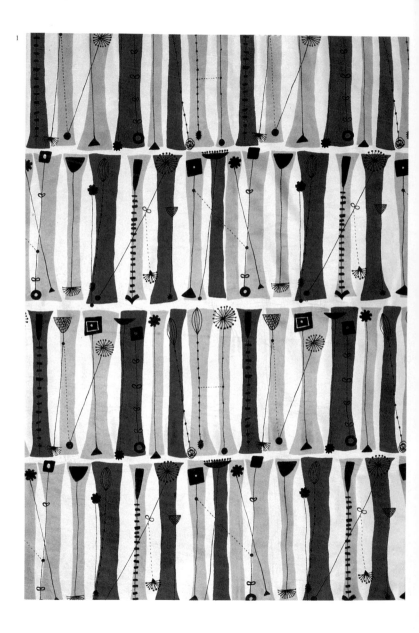

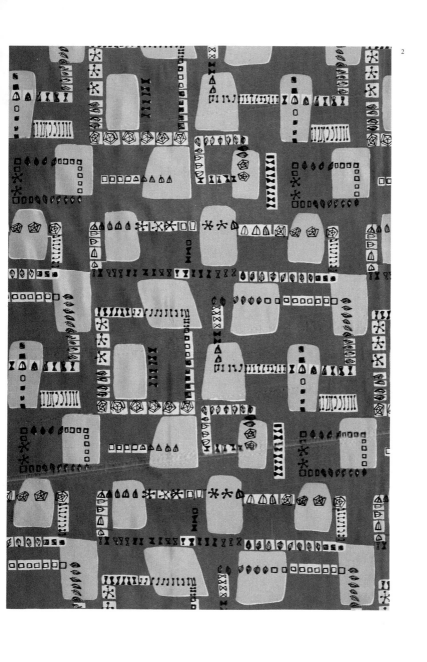

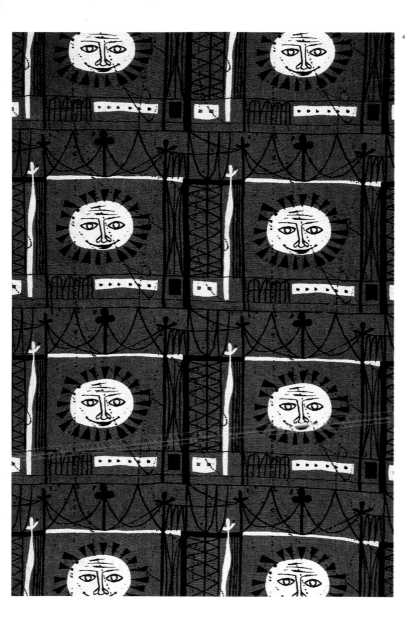

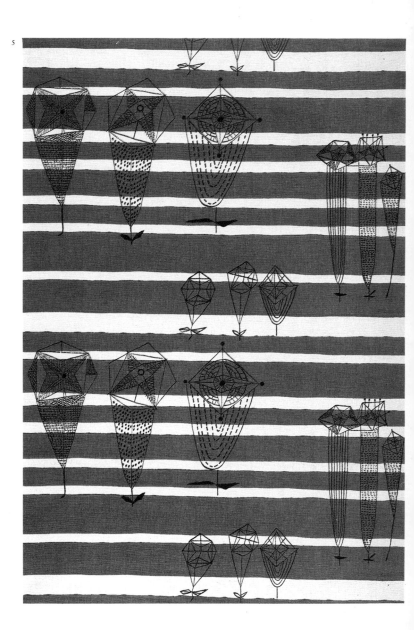

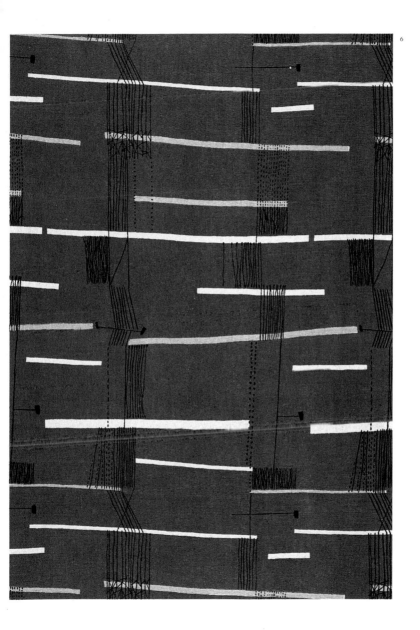

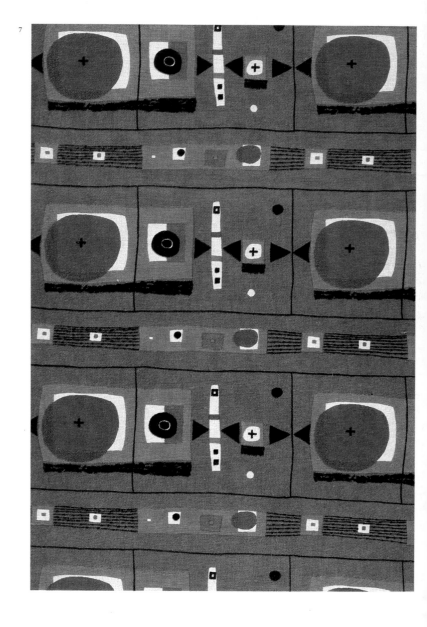

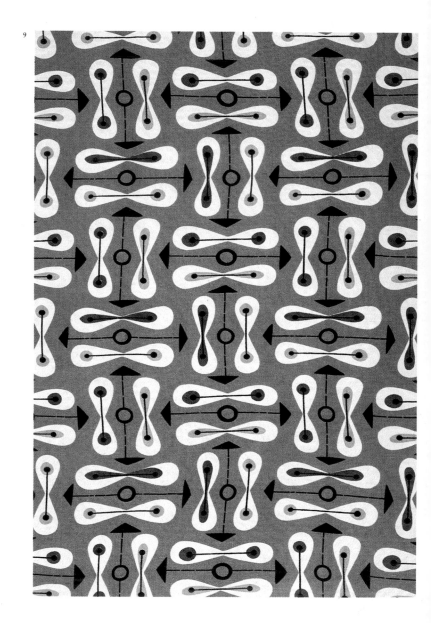

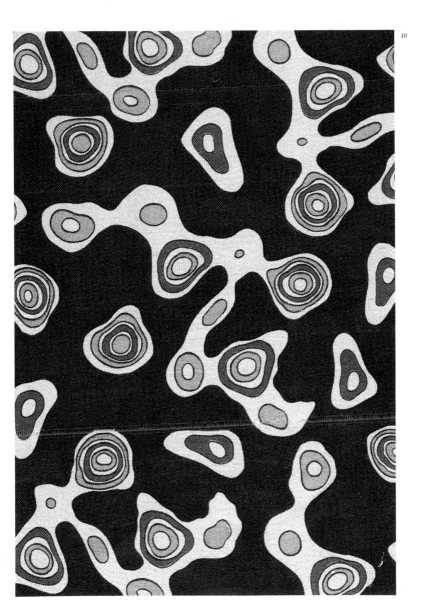

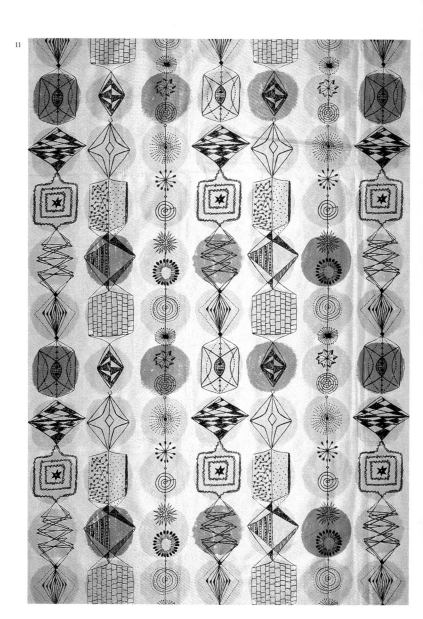

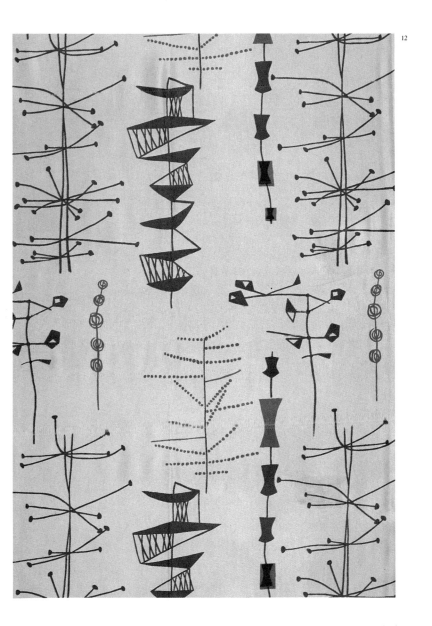

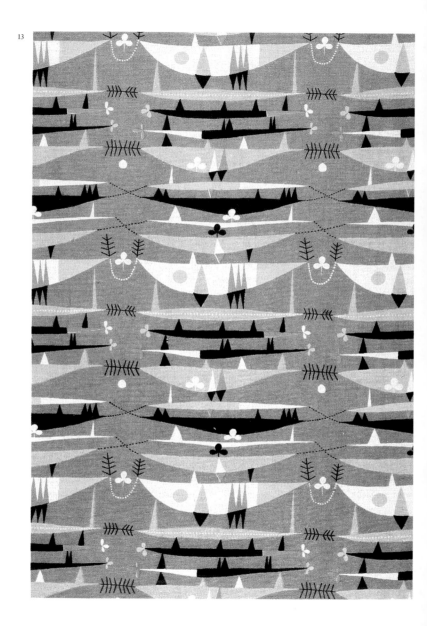

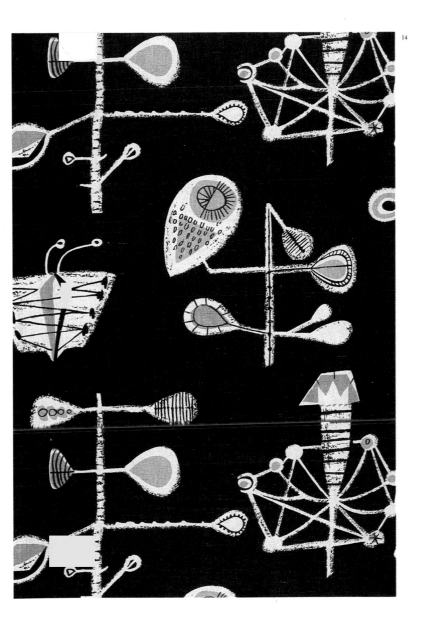

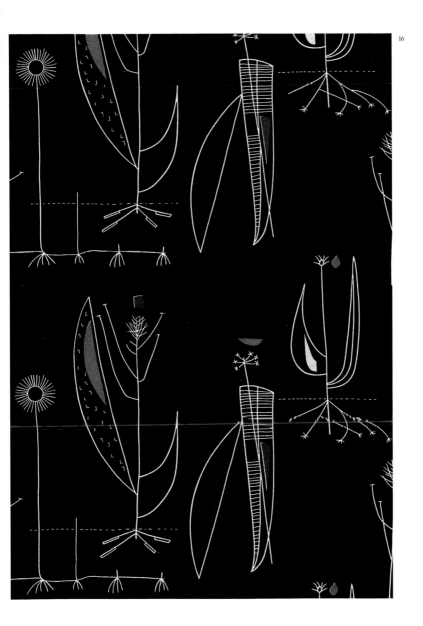

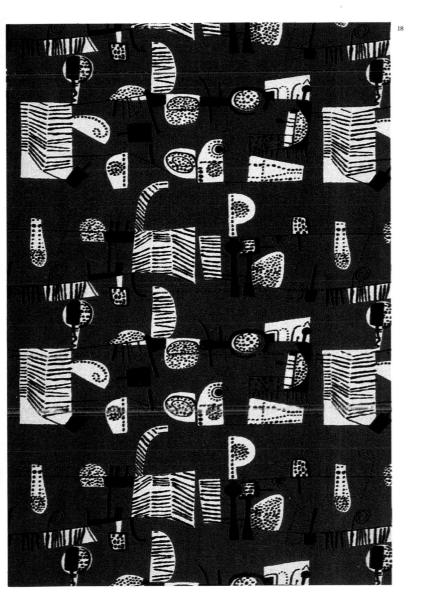

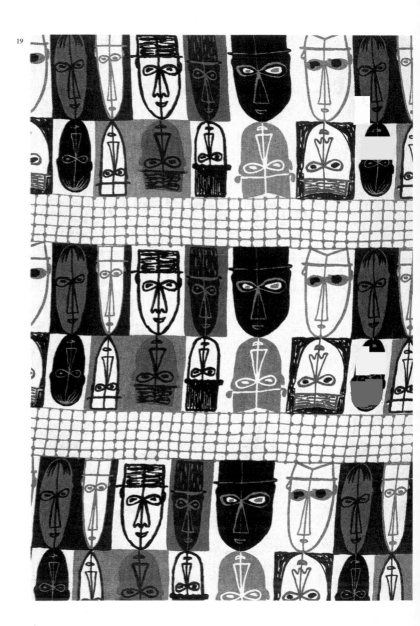

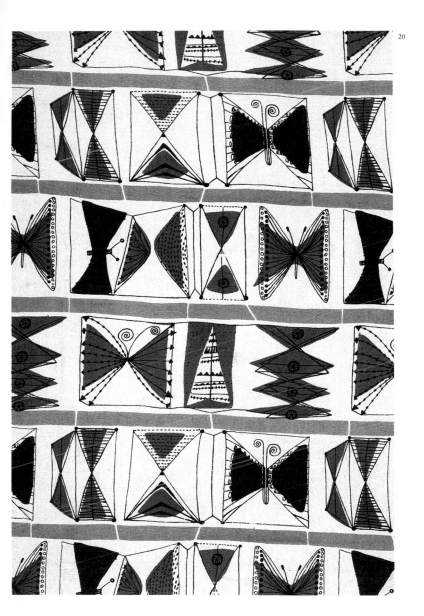

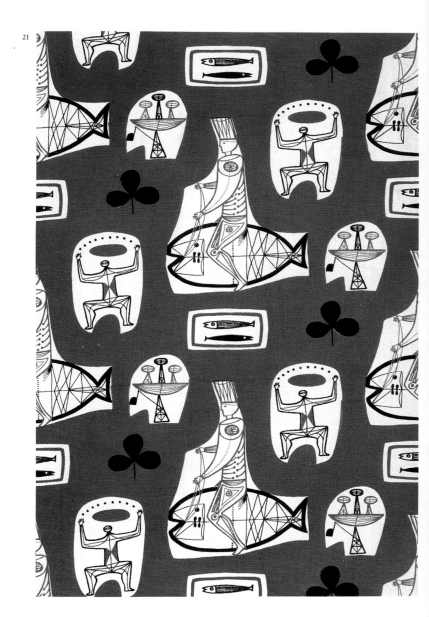

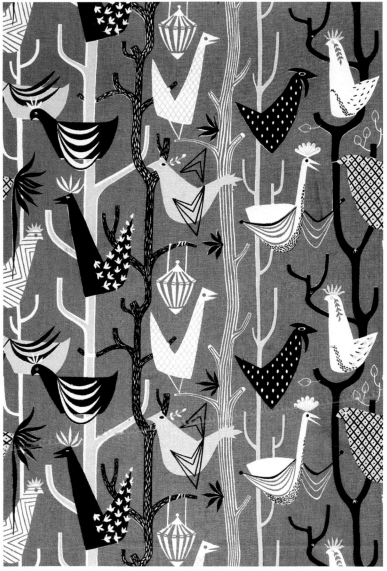

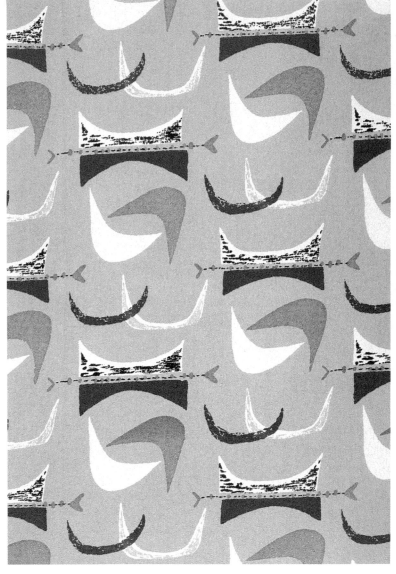

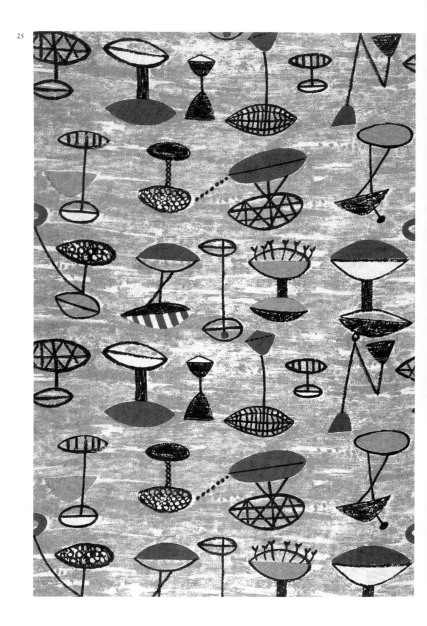

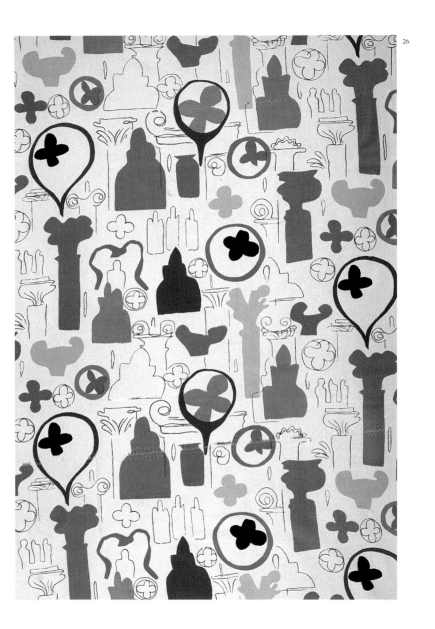

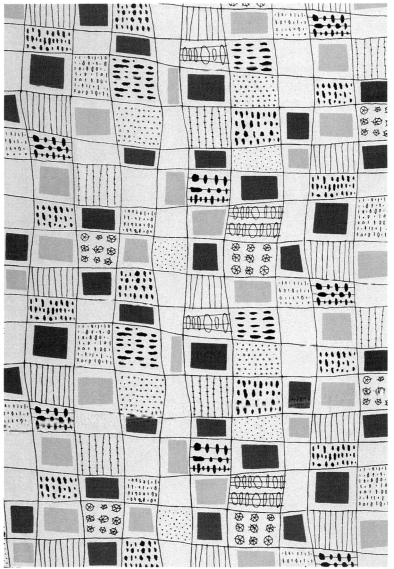

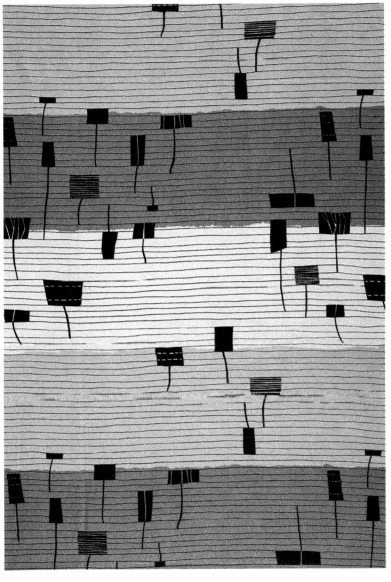

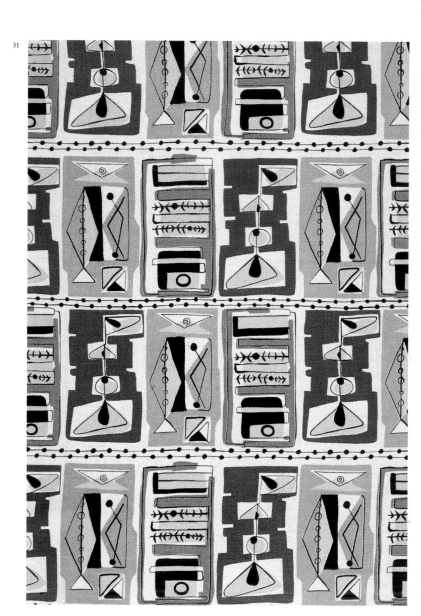

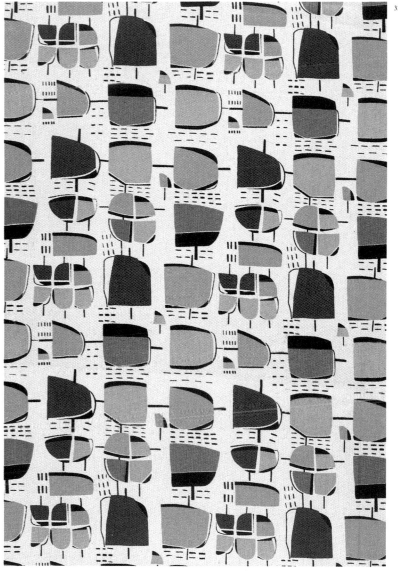

THE
VICTORIA
& ALBERT
COLOUR
BOOKS

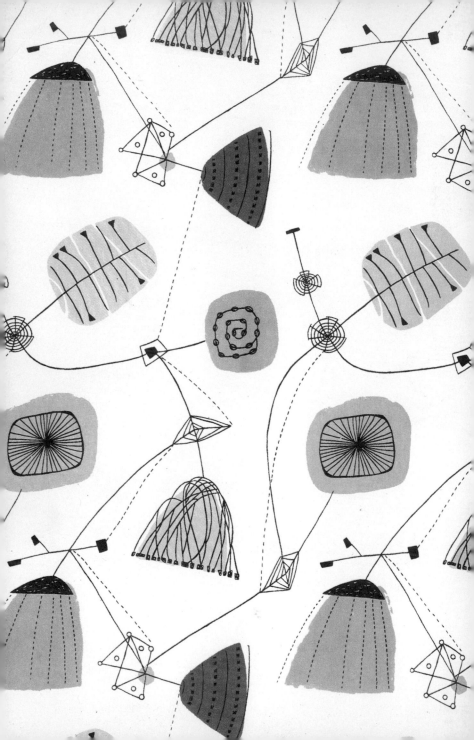